THE RIGHT WAY
TO DRAW

To Derrick, Mary, Pat and family
for their priceless friendship.

THE RIGHT WAY TO DRAW

Mark Linley

RIGHT WAY

CONTENTS

1

YOU CAN LEARN TO DRAW

Yes, you really can! Many people think that learning to draw is difficult if not impossible. In fact, it need not be. If would-be artists treated the subject as fun and went about it in the right way, it could be possible for nearly everyone, like learning to drive. At first it may seem hard, but not if the basic instruction is correct.

Expect mistakes

When tackling any new skill it is common sense to accept and expect that lots of mistakes will be made. It's part of the learning process. It is not unusual for students with no previous experience of draughtsmanship to suddenly discover that they can put down accurately what they see. It requires just three things for this to happen:

1. The ability to look properly
2. Self-confidence
3. The capacity to remember and carry out basic instructions

You have the touch

I have not mentioned skill with pencil, pen or brush. The reason is because all who can write their names, already have sufficient touch and control to make a multitude of complex shapes – called the English alphabet. There are no harder lines, in nature, to record.

A semi-illiterate navvy with scarred, calloused, insensitive hands and a tendency to drink too many pints might start off

at a disadvantage. But there are talented handicapped artists
with no fingers who can draw; some use their feet, or mouths.

Think positive

Folk who learn quickly are often those who have
enthusiasm for their subject and self-confidence. The way we
think is vitally important to the way we operate. Many of us
are brain-washed from childhood into thinking negatively
about some things. We have all heard others say, for
example, "I can't draw a straight line." When this is thought
or said it becomes a command to the human computer, the
sub-conscious mind, which then obeys the instruction by
programming the individual to this end. "I can't" is then a
barrier for as long as it is thought.

Think negatively and you will be programmed to do
exactly what you have thought. You will never be able to
control a pencil or pen well enough to put down the lines you
see. You won't be able to observe shape accurately, or define
texture, and, of course, it will be your own fault.

You have bought this book, so you are probably already a
positive thinker; if not, you will be from now on. How do you
do this? Very easily, just think and say, "I can learn to do
anything" then forget about it. How long will it take? About a
tenth of a split second or faster. What's more you can apply
this simple rule to any subject for the rest of your life. You
will have no barrier to stop you moving forward. It may
encourage you to know that I am a self-taught artist.

Gifted?

I believe the term 'gifted' is too lightly used in respect of
artists. Only one in every million or so can be truly said to be
gifted. The rest of us are craftsmen with different degrees of
skill. If you can write your name then you have enough touch
to learn to draw. If asked to write an A, G, R, or K you could
do it without thinking. Well, within these pages you will not
be called upon to draw anything harder than that. Most lines
in nature are gently curved, wavy, or straight; even those that
appear complicated at first are not if examined closely.

This is why it is vitally important for us artists to look

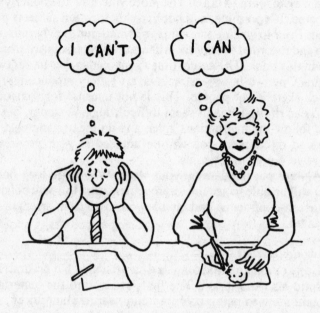

Fig. 1 Yes, you really *can* learn to draw!

properly at what we want to record. If our drawing goes wrong it is always because our looking was at fault. If, for example, you draw your spouse with a broken nose, cauliflower ears and crossed eyes when in fact the features are more or less normal, then your viewing is wrong or your humour wicked. If your sketch of the family moggie turns out to resemble a furry crocodile then you haven't focused correctly, or need glasses.

Looking properly is important and will be touched upon again, frequently, later in the book.

Churn them out

Some amateur artists believe they're doing well if they turn out three or four drawings in a week, but this is almost useless as a way to learn to draw. The more you draw the better you become. It's possible, and not hard, to draw ten subjects per hour. Prior to writing this chapter I wandered slowly round a zoo and recorded twenty six different subjects, some of which are in this book. The actual time spent on this was under two hours. One two-hour session in an art gallery produced forty quick sketches of people. This is not unusual for someone who can draw. It might seem difficult for a beginner, but if you follow the instructions given and do the assignments at the end of chapters you will be amazed at your progress, creative output and genius.

Always put the date on your work. When you look back you will be able to see the improvement, and this will bolster your self-confidence and enable you to go from strength to strength.

Cavemen artists

Early caveman could draw and carve simply but accurately, despite his small brain! The first artists used the materials around them to paint: coloured clay, earth, plant juices, all applied by stick, or fingers. Today we have a wonderful selection of art materials to choose from, and start off with a tremendous advantage.

Materials required to start

For the exercises in this book you will need a few soft lead pencils (HB), drawing pens (fibre-tipped or ball point), a small brush, eraser, and an A4 sketch pad. Details of what to use are given as we progress, and other materials will be suggested along the way. You may prefer to use crayons, coloured pencils, or pens. Choose what you are happiest with. Picasso tended to use whatever was at hand, you might follow in his footsteps, who knows? What do we draw on? Any smooth surface would do, including the tablecloth, but a good cartridge paper sketch pad with a cardboard back is the best. You may treat yourself to a classy drawing board,

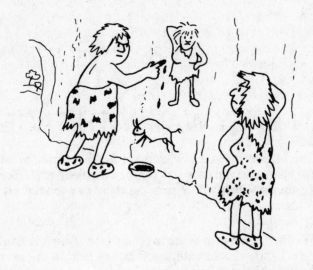

Fig. 2 Early caveman could draw, despite his small brain!

or table easel, but most times, particularly when sketching from life, these aren't necessary.

The right grip

How do you hold a pencil to draw with? The way that is most natural and comfortable for you personally. Not too tight, relaxed and under control. How do you control a pencil? Usually with your eye, brain, tip of an index finger and side of a thumb, but we all have a slightly different grip.

2

AN EASY WAY WITH FACES

The human face can be difficult for the novice artist to draw, but there is an easy way that just requires remembering three things which will ensure the right way to start off.

The profile

We shall begin with a face in profile (seen from the side). It will be lightly drawn with a soft pencil held in the normal style to write. Look carefully at figures 4 to 7 then draw the basic skull shape. This is like an inverted triangle with rounded corners and one side vertical.

Half way down, from top of the skull to bottom of the chin, you put in an eye. This can be like a V but laid sideways and filled in. Have a look at figure 5. The eye should be put in slightly behind the front line because the bridge of the nose is beyond it. Check this on yourself by passing a finger across your eye until it hits your nose.

The underside of the nose goes in next. As figure 6 shows, this is half way between the eye and the bottom of the chin. It can be a straight line, tilted up, or drooping down – as people's noses do.

Put the mouth line in after this. This is half way between the bottom of the chin and the nose. The mouth line can be straight, curved up or down. A line that sweeps up, as you may know, denotes happiness. Why not start with a happy face?

Your sketch should now show the correct proportions for a face with eye, nose and mouth in the proper places. Now put

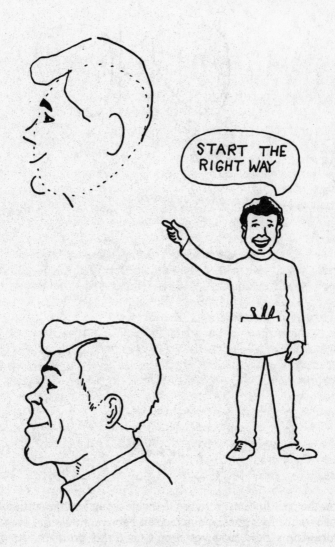

Fig. 3 An easy way with faces.

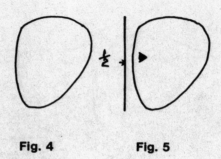

Fig. 4 Fig. 5

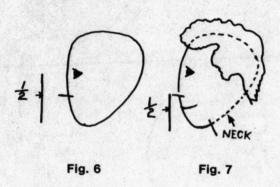

Fig. 6 Fig. 7

The Profile

in the hair line, as in figure 7, by drawing just the outline of where the hair goes on the face and above the skull. If you're drawing a bald man you won't have this problem. At this stage it isn't necessary to try and draw each hair as some beginners do. The highest form of art is to suggest things by as few lines as possible.

Hair

 Ask yourself if the hair is wavy, straight, fuzzy or whatever, then jot it down, see figures 8 to 11. I've used a mechanical tint on two of the faces to get the effect of colour. This is transparent and has thousands of tiny dots. It is stuck down on the drawing then cut to shape with a sharp blade.

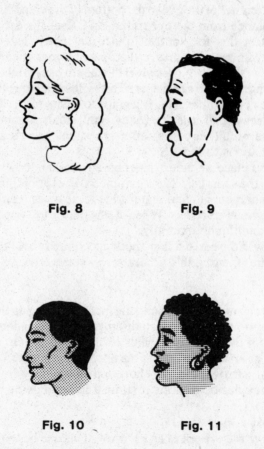

Fig. 8 Fig. 9

Fig. 10 Fig. 11

There are many different types and styles of hair.

Be a people watcher

Try to get into the good habit of looking at people you meet and mentally drawing them. Later on you will be able to draw them when they have gone, or quickly sketch them from life.

Ear, ear

Before we put in details we must draw the ear in the right place. This is done by measuring the distance from the outside corner of the eye to the bottom of the chin; this equals the distance from the eye to the BACK of the ear.

To test this for yourself, place an index finger on the outside corner of your eye then extend your thumb to the bottom of the chin. Now swivel the thumb back while keeping your finger on the same spot. This will bring your thumb to the back of your ear. This is a guide to where to put the ear in your drawing. If it isn't exactly right, don't worry about it because we all vary in small degrees, and there's a million combinations to faces.

If you place an index finger on an outside corner of your mouth, the same side as the ear, then swivel your thumb back to the ear, you will find that it's the same measurement as in the previous exercise. When doing these tests relax your finger and thumb naturally.

Draw in the ear, but don't bother too much about the inside structure. Getting this accurate will come later.

Noses

You can next start to build the face by joining up the end of the nose to the forehead, and remembering to indent for the bridge of the nose. Feel your own, just to check, or use a mirror as an aid. The line of the nose can be hooked, droopy, broken, narrow, long, or short depending on your subject. You may decide to draw it straight to begin with.

Eyebrows, eyes and things

Above the eye put in an eyebrow. This can be thin, bushy, arched, straight or barely visible. Have a look at figures 12 to 15 for examples of different types.

Fig. 12 Fig. 13

Fig. 14 Fig. 15

A few examples of eyebrow shapes.

If the face you are drawing has age lines, bags under the eyes, war wounds, dimples, or other marks, draw these in lightly. Now clean up your picture with an eraser. Haven't you done well?

Now for the neck lines. This causes some folk bother because they don't realise that the neck comes out of the chest at an angle of about 15% and juts into the skull. It is not straight up from the body. Hold a pencil by the tip so it is

pointed vertically up then tilt it to one side about 15°, this will give you the angle to follow when you add a neck to your drawing. Have another careful look at figures 8 to 11 then do this.

When drawing from photographs or from life, you will notice whether necks are long, short, fat, thin, or scrawny, but for now just get the slope from the rib cage about right.

When you become used to drawing the basic structure quickly – skull shape, eye half way down, end of nose half way from eye to chin, mouth half way between nose and bottom of the chin – you can try to record finer points, but more about this in later chapters.

The full frontal face

To draw a face from the front, imagine it as an egg. Draw an egg shape with the pointed end at the bottom, then draw in very lightly a line down the middle and one across half way. See figure 16. The half way points for eye, nose underside, and mouth are just the same as in your profile drawing, so the main difference is the egg shape as opposed to the skull outline of your last drawing.

Put in the eyes, end of nose and mouth as in figure 16. Look at figure 17 to develop the drawing by adding ears. These you will see look slightly different from the front. The top of the ear, generally, is in line with the eyes, and the bottom is level with the bottom of the nose. When drawing from life, ask yourself if the ears stick out, are close to the head, are long, short, or have an edge which protrudes. Draw in the ears, then draw in the hairline as you did for the profile. Figure 17 also shows different hair styles, lips, mouths, and other parts. Draw in the missing pieces then erase the lines you don't want. Select your best effort and have a go at inking it in with a fibre-tipped pen. When this is dry rub out the remaining pencil marks and pat yourself on the back – if you deserve it, and I'm sure you do.

As you master these first basic structures and draw quicker, you should try to sketch faces that are turned to one side. The way to do this is to remind yourself of the egg shape,

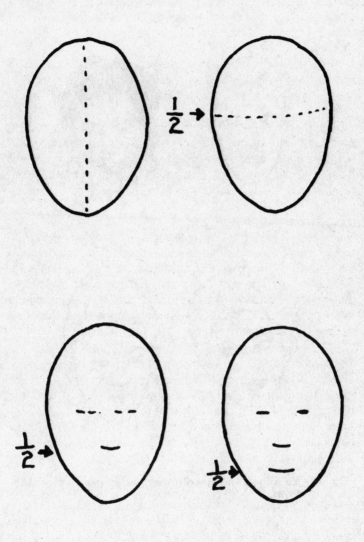

Fig. 16 Drawing the full frontal face.

Fig. 17 Ears look slightly different when drawn from the front.

and begin by drawing it so, then lightly put in dotted lines in curves as they would appear if you did them on a real egg. To check, draw them on the hard boiled one you are going to have for breakfast!

**Fig. 18 Try using an egg with plasticine features as a
model.**

Use an egg

An egg with bits of plasticine stuck on for nose, ears, and
chin is an excellent model to practise on. See the examples in
figure 18, then try to mould plasticine like a face, chosen
from these drawings. You won't be able to model details like
eyebrows or hair, but even a rough job will give you a good
idea of how a face is constructed and will be an aid to
sketching faces.

Fig. 19 Try drawing a head that is looking up or down.

With or without the help of an egg, try to draw these faces then ink in the best. Erase pencil marks and give yourself another pat. You're on the way to becoming a good artist.

Lots of looking

It is important to spend more time, at first, looking at your subject than on the actual drawing. Most people, when asked to draw something, immediately begin before giving themselves a chance to observe their subject properly. To do this is to make the job much harder, so look well before starting.

You may like to try a head that is looking slightly up or down, and the way to do this is shown in figure 19.

With practice you should be able to copy all the faces in this chapter, and have enough self-confidence to move on to something more ambitious. Now try the following assignments before reading the next lesson.

Draw the profile and front face of four people from magazines or newspapers; remember to use the same basic rules which you have now learned. Then try to draw two sketches of someone who will pose for you for two or three minutes.

If you live alone, attempt a self-portrait by looking in a mirror. Vincent Van Gogh did many of himself because he couldn't afford a model, and had few friends around, poor chap. In years to come your effort might be worth £24 million!

3

HOW TO MAKE IT SIMPLE

No matter how good an artist is, if the drawing is started off with the wrong basic shape it will always be wrong and look so. As a simple example, if a square barn is sketched and the first drawing shows it as being oblong with rounded corners then all the attention to details and correct shading will have no effect because it's not the right shape. In the same way, if you want to draw a stocky, short person and you begin with a tall, thin one, the finished picture can never be right.

Look first

This chapter is devoted to keeping our drawings as simple as possible. To try and do fine, detailed art while learning to draw is very difficult and awfully confusing. If your attempts are more basic than the examples shown then that's fine.

We start off the right way by simply looking at our subject and mentally noting the rough shape which we can jot down in pencil. We can use the same pencil, held at arm's length, to decide if a thing is upright, sloping, or to gain an impression of size. You should close one eye when doing this. A pencil can give you an idea of how lines are – if they are curved, irregular, or more or less straight – and is particularly useful when drawing perspective.

Stick people

A help in drawing people is to begin with a stick person then thicken it until it's something like the real thing. See the examples in figure 20. If we sketch a man wearing a suit,

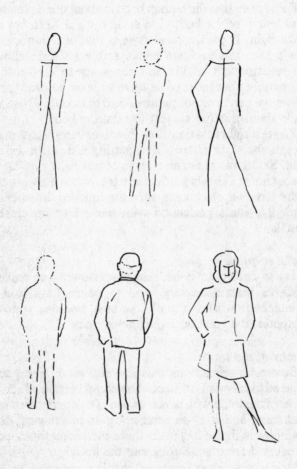

Fig. 20 Start with a 'stick' person.

we could put down a square for this with the head, legs and shoes added.

Most beginners avoid drawing stick people because they feel that it's a sign of being unable to draw. Of course it is! So what?

If a method of learning works for you, "stick" to it.

Remember that the human head is about one seventh of the total length of the body. Do several quick sketches until it looks right. If your natural style is that of a cartoonist you won't have this problem because this art form allows the greatest freedom, and it isn't necessary to keep to life-like proportions, but most of us have to learn to draw properly before we can turn our pictures into cartoons. There will be more about this fun subject later in the book.

To get it right first time then, involves careful looking at the overall shape, or shapes, and putting it down more or less right. Small mistakes can always be put right, but large ones almost never. This is particularly true when drawing people. If the basics are accurate, then the finished drawing can be fiddled towards perfection with the aid of an eraser and pencil.

Make it quick

Try to draw quickly because to go slowly is to make more mistakes than necessary, and to cause hesitation. Fast spontaneous work is usually the best, because your inbuilt computer, the sub-conscious, helps you.

Tricks of the trade

Before we spread our artistic wings on different subjects we need to know a little about how to get certain effects, a few tricks of the trade with pencil or pen. The commonest method is shading and it is an essential part of drawing. See the examples in figure 21, study these then copy them, you will be using these often throughout the book.

Notice that most forms of shading are done by simple strokes which may be vertical, diagonal, curved or haphazard. When lines are crossed over, this is called cross hatching, and it is very useful for depicting deep shadow, or dense patches.

A tree

Make a start on a drawing now by sketching the tree in figure 22. Jot down the rough basic shape first with thin

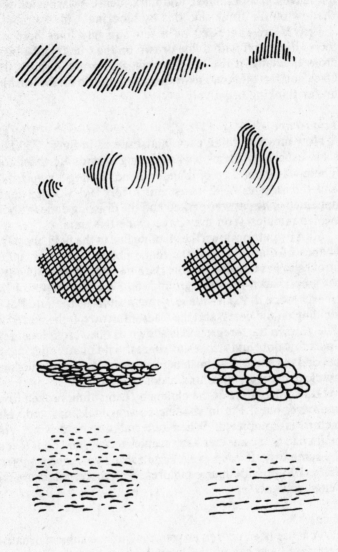

Fig. 21 Some examples of shading.

broken lines in pencil. Next add the small areas of shadow in the leaves and branches, and dark, dense splashes of deep shadow on the trunk. Do this by blocking it in.

Leaves are suggested by a few squiggly lines here and there. Finish off with a line or two on the trunk, and a bit of cross hatching at the base to represent grass. Wasn't that easy, and fast? If your answer is no, go and do all the washing up for thinking negatively.

Landscape

Now move on to an easy landscape as in figure 23. This scene caught my attention when driving towards Northampton. There was a build up of thunder clouds during a sunny day, and the sloping field, trees and lovely old wooden fence appealed. The car was parked and the drawing done in about twelve minutes. You may have twice this time.

Start by putting down the slanting line of the field, the basic shapes of the trees, and the fence posts. Use close, quick strokes to get the effect of the dark line of the distant hedge, the tree shadows on the ground, and the dark parts of the trees. Notice that one side is lighter as it faces the sun. Put in shading on the posts, and the tractor furrows in the meadow. The grass in the foreground is shown as open cross hatching, and a few dots and strokes to suggest wild plants sticking up beyond the fence. The bush in front of the fence is again done by close squiggly lines and a dot or two.

Draw the outline of the clouds by using thin, broken lines and curly ones. Put in shading by diagonal lines and your picture is completed. When out walking, or driving, you might like to try another easy scene like this, and do it in just the same way. If you have a large garden you have a subject that could provide many pictures. The more you draw the better you get.

A cat

A cat has been chosen as your first animal subject because once you have gained the knowledge of how the head and body are drawn it will always be very similar for all moggies, big or small, in future pictures tackled. Cats are a great

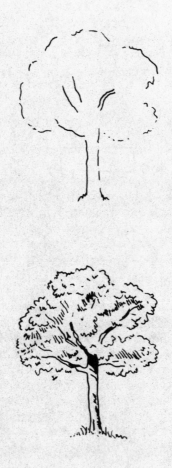

Fig. 22 Jot down the basic shape first, then block in the rest.

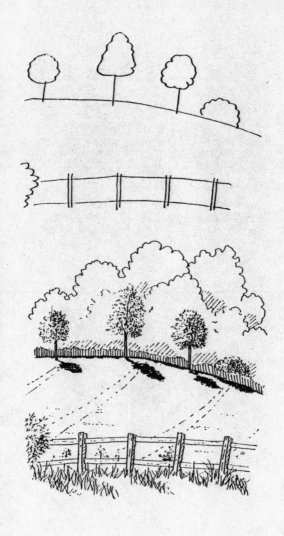

Fig. 23 An easy landscape.

subject and offer many different shapes whilst awake and
when asleep. Dogs are different. They vary a lot; there are
scores of different breeds with big changes in their anatomy;
they are harder to draw because of this.

Begin by copying the basic shape in figure 24. Do the head
next and note that a cat's nose is short, ears and eyes large,

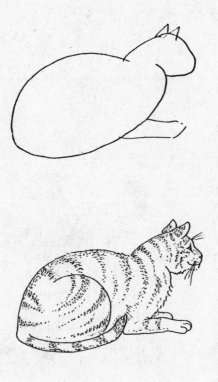

**Fig. 24 A sitting cat is an easy, rounded shape for your first
animal drawing.**

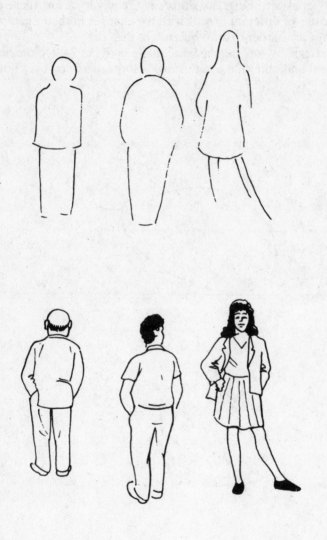

Fig. 25 To start with, go for a fast, accurate sketch.

the forehead is pronounced in cats, and they are always smiling. See the curved up line of the mouth. A sitting cat presents an easy, rounded shape. The fur is suggested by fine shading, but these lines must run the same way as the fur grows on the real thing. Put the whiskers in with thin, delicate lines and that's another masterpiece finished.

People

You should try people now. Have a shot at those shown in figure 25. Don't bother with detail at this stage, go for a fast, accurate sketch. Begin by having a good look, as usual, then jot down the basic shape. Fill in the outline by quick, simple lines, and you have progressed further. If you are confident, the best thing, of course, is to try and draw everything from life, but otherwise plod along with copying for the moment.

All the subjects in this chapter will be covered in depth further on in this book.

Assignments

1. Draw two different trees from life using the technique you have just tried.
2. Draw a cat sitting, or walking, same method.
3. Draw from life two people as simple sketches.
4. Draw an easy country or park scene.
5. To back up chapter 1, draw two faces, one in profile, one frontal.

4

WHAT A FACE!

We are going to do more with faces this chapter, and, of course, base all our sketches on the right structure taught in chapter 2.

Faces everywhere

Though you may live on your own, you need never be short of models to draw. To prove this point, all the faces in figures 26 to 29 were drawn from just two daily newspapers and a mail order catalogue. In fact, there were over fifty faces to choose from. There are famous people and unknown ones, all very interesting for the artist. Little detail has been drawn.

Newspapers use cheap paper that doesn't allow too much definition as compared with a glossy magazine, but this can be an advantage when learning to draw. Have a close look at some of the examples and see how eyes may be simply blocked in, mouths expressed as a single line, and hair just suggested.

Try copying some of these drawings to start off with. Begin by drawing the basic egg-like shape or the skull profile, using the dotted line technique which you previously tried. When you are satisfied with the result, rub out the pencil marks, then ink in.

Test the method by putting tracing paper over the examples. Draw on it the dotted lines for each face, then complete the drawing as seen through the tracing paper.

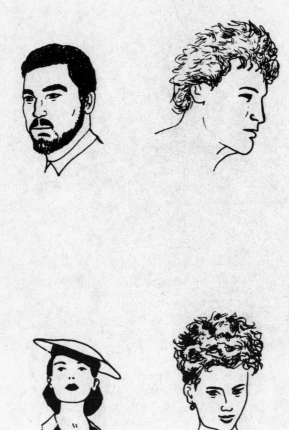

Fig. 26 There are interesting faces everywhere!

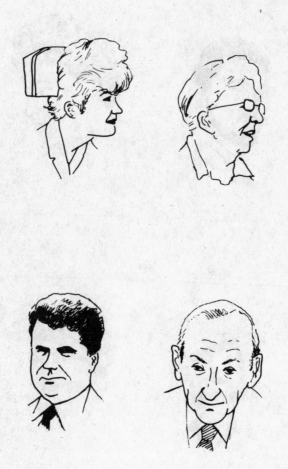

Fig. 27 If you live alone, get your 'models' from
newspapers or catalogues.

Fig. 28 Keep your faces simple.

Fig. 29 When drawing teeth, don't draw them!

You're looking good

A good way of learning how to get expression right is to use yourself as a model. Use a large mirror and do a bit of acting; grin, scowl, look angry, haughty, shocked, or whatever you fancy, but have a close look at what your eyebrows, mouth, and eyes do. Study your striking film star profile by using more than one mirror. It's all there for you to see.

If, like Van Gogh, you use yourself as your own model, don't be put off by mistakes or be tempted to flatter yourself too much. Should you go slightly unhinged, please don't hack off an ear or do anything so drastic – enjoy your madness just like I do.

Models

If you live with a group, spouse, friend or family turn on your undoubted charm and ask someone to pose for you for a few minutes. Get into the habit of looking longer than drawing and this will help you, and prevent your model from freezing, or getting bored with one pose.

A good tip about drawing teeth is not to draw them! See figure 29 and notice that teeth are suggested by a blank space. This is the most effective way of doing them, unless a large poster advertising toothpaste or tooth care is required.

You could use your worst enemy as a model, or folk you don't know, but try to draw them when they are not aware that you are doing it, otherwise you could end up with a black eye, or ruined picture. I must confess to drawing hideously funny cartoons of the people who sometimes annoy me. Watch out if there's an irritated cartoonist about!

Expressions

Another aid to learning how to get expressions is to draw cartoon faces either from published ones, or from those taken from life sketches. This is explained further in chapter 13. Have a close look at figure 30. A scan through daily papers is useful is you can learn from the cartoons and photographs how faces are shown.

Photographs are useful to all artists and particularly to beginners. Copy as many as you can, trace a few, break them

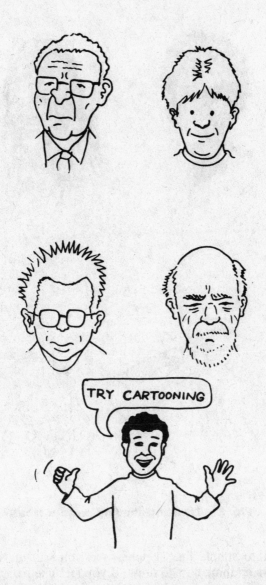

Fig. 30 There are many facial expressions you can try.

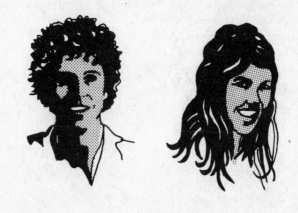

Fig. 31 Try using shading on your faces.

down into simple line sketches and you will make rapid
progress learning how to draw. If you feel like being a little
more ambitious have a look at figure 31. Notice how a face
can be blocked one side as if in shadow, or shaded with

diagonal or horizontal lines to give yet another effect. Try out both techiniques with some of your face drawings. Begin with light pencil strokes, then ink them in when you are satisfied. Practise drawing faces from different angles and of different races as in figure 32. Later on you might try drawing straight

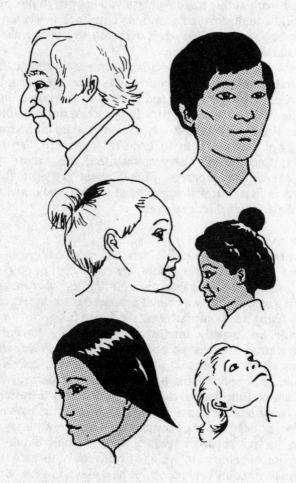

Fig. 32 Practise drawing faces from different angles and of different races.

off with ink as this seems to intensify concentration, and, surprisingly, tends to cut down on mistakes, increasing self-confidence.

To re-cap on earlier pages, do not attempt super, fine detailed work at this stage – unless you happen to be one of the world's undiscovered geniuses. This book is written for the raw beginner who just wants to be able to jot down simply and accurately what is seen.

Many of us live in towns or cities and we are surrounded by thousands of models. Once courage has been plucked up, we can go out to draw from life and there is no shortage of faces or bodies to practise on. A trick to use when drawing folk is the one already mentioned – try to sketch when the victim is unaware of what you're up to. Look for long spells then draw quickly, and never worry about mistakes, these will disappear as you progress. Forget about getting a facial likeness at first, this will come the more that you draw, and very likely faster than expected.

Where to go

Corner seats in busy cafes, bars, tea rooms, libraries, art galleries, and many other places, are good vantage points to work from. You can even draw from the top of a shaking, bouncing bus, and the wavy lines produced from this actually add to funny cartoon drawings, see figure 33.

People are usually interested and friendly towards a working artist so never be put off by crowds. Once, when drawing abroad, I went into an almost deserted coffee bar because I had spotted and heard a screaming parrot which was crammed into a small cage. I ordered a drink then started to do a very detailed pencil drawing of the poor bird. As time went by I noticed that the bar manager's face grew longer and longer, for no apparent reason. After a spell, I had the impression of being watched, and turned round to see a large policeman standing behind me. He held massive arms across the doorway to prevent customers from entering in case they disturbed me! He smiled widely at me, but I felt divided by embarrassment and gratitude. I finished the picture rapidly,

Fig. 33 Drawing from a bouncing bus can produce wavy lines, greatly adding to a funny cartoon.

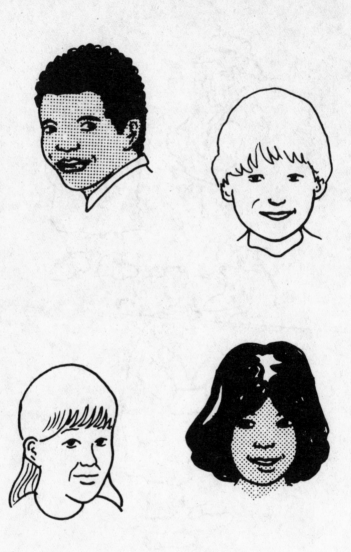

Fig. 34 Children's faces are harder to draw.

gave it to the gloomy man behind the bar, and charged off into the bright sunlight. Funny things sometimes happen to us artists.

There is a slight difference in technique between drawing male and female faces. Men tend to have rugged, beaten up looking mugs, whilst ladies are much more delicate, smooth and gentle. It pays to use thinner lines when working on a woman's face (or a child's), but heavier lines go more with a man's face. If you are using a pencil, make the point sharp for girls and blunt for men! I prefer to draw most originals on tracing paper because it has a very slick surface and feels nice to work on. You may find that ordinary typing paper is pleasant to draw on. It's worth trying several pens and papers just to find the one you like the best.

Children

To start with you may find that children's faces are hard to draw, there being no age lines, heavy bags under the eyes, or distinctive jaw bones. Children have larger heads, in proportion to their bodies, than adults. This is because a baby is born with a relatively big head. During childhood the head grows much more slowly than other parts of the human body. Have a good look at figure 34, see how round the faces are, and what is suggested by a few lines.

Assignments
1. Take two newspapers then draw ten faces from them. Trace the first four only, do the other six freehand.
2. Use a glossy magazine then repeat the above.
3. Draw from life four faces.
4. Ink in your best work, and date all pictures.

5

HANDS AND FEET

Hands, for the newcomer to art, are probably the most difficult part of human anatomy to draw accurately. So we shall start at the other end by having a look at feet first. To make it easy we will begin by sketching old boots. If you don't possess a pair make do with a glass slipper or the latest thing in man-made plastic.

Footwear

Drawing different footwear is first class practice, and good grounding before moving on to bare feet and hands. Have a long, careful look then put down the basic shape. Men's shoes, seen from the side, are usually wedge shaped, but women's shoes vary enormously; they can be flat soled, high heeled, pointed, square, cut away, or have many variations.

Sketching footwear is interesting with so many models around which we see daily. If you are unable to get about much, you might care to use your friends as models. Just tell them that you are going to record their tatty old boots for posterity, or want a study for a book. This never fails!

Have a look at figure 35, then at figure 36. The drawing of a worn slipper, bottom left, is a bird's eye view. We see part of a wrinkled, decrepit sock. This is my own right hoof!

It will help you if you draw as many different pairs of footwear as you can, and from different angles. Start with your own; a mirror could come in useful here because you can see your feet from different sides. Try to do quick ink sketches similar to those shown in the examples.

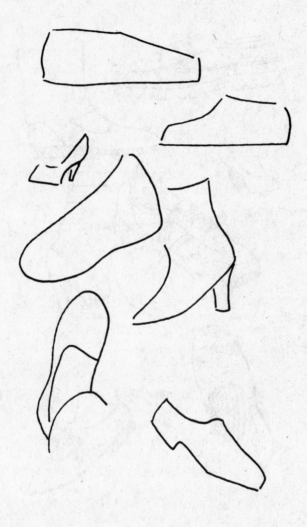

**Fig. 35 Drawing footwear is good practice before moving
on to bare feet.**

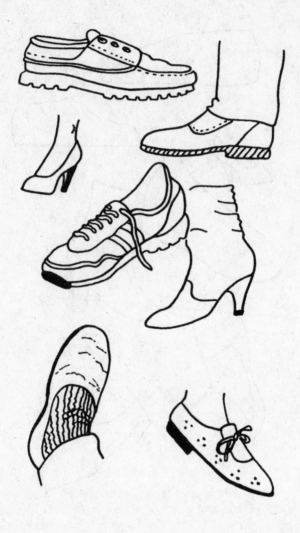

Fig. 36 There are many variations of footwear from which
 to choose.

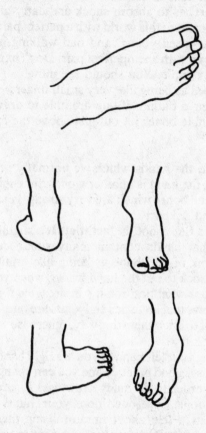

Fig. 37 Try drawing bare feet from different angles.

Feet

Now try to draw bare feet. Again you can use your own or those of friends, and a mirror, or combination of all three. See figure 37. Feet are basically the same shape but there is one thing that is different. What is that? Toes vary with almost every individual; they can be thin, fat, long, short, or often crowded – ask any lady who habitually wears pointed shoes.

The human foot is a wonderful structure of 26 bones arranged in arches to absorb shock and carry great weight. Most of us come into this world with a perfect pair, but due to poor footwear when young, and bad walking habits when older, we end up with an imperfect pair. Don't expect to draw a text book example. You should see mine!

Think of toes as being like very small fingers, with the big one resembling a thumb. If you are able to draw from life, notice how ankle bones jut out just above the foot.

Hands

Unlike feet, the hands which we normally see are bare. Like the foot, the hand is another wonderful engineering job of small, braced bones which are very strong, yet allow much movement and dexterity.

A hand laid flat is not, in fact, flat. It's slightly rounded. Remember that hands contain many subtle curves. It is helpful to think of the shape as being like a mitten. Just a thumb and a sock to put the hand in. So, when you look at a hand, no matter what position it's in, imagine it as a mitten. Figure 38 shows that knuckles and joints are on a curved line. It is important to draw them this way, otherwise what you put down will look flat.

Try drawing your left hand, if you are right handed, or right one if not. This is good practice and you can change the shape or gesture in order to do many drawings. Figure 39 shows different positions. Here, once more, your chums could come in useful. Spin a tale about immortalising them for their beauty. If your friend happens to be a road mender think of something else.

The palm of the hand, and the back, are rather square with thumb and fingers stuck on the end like slim, or fat, fish fingers. There is a large pad of muscle from the base of the thumb which rises across the bottom of the palm. There is a change of shape where the hand joins the wrist. This is often marked by wrinkles. Have a good look at your own.

There is quite a difference, usually, between the rough, hairy paw of a man, and the delicate, smooth hand of a lady. See the examples in figure 40.

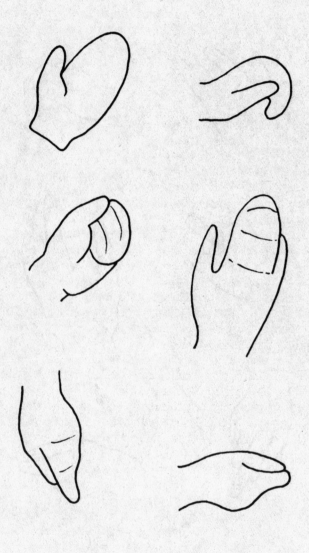

Fig. 38 The shape of the hand is like a mitten.

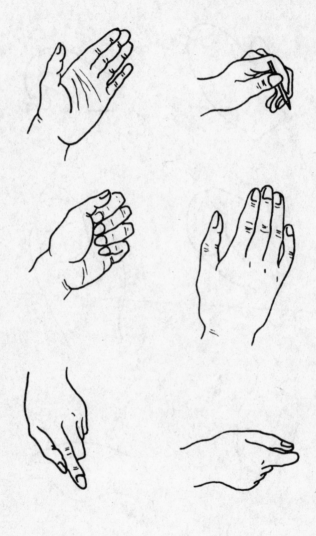

**Fig. 39 You can change the shape or gesture of hands to
do many drawings.**

To give you an idea of how the hand is curved, you might try putting a coloured chalk line across the joints and knuckles. If you try this don't use permanent colour paint as I did!

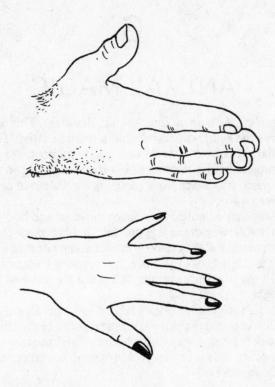

Fig. 40 There is quite a difference between men's and women's hands.

Assignments
1. Draw two pages of footwear, both sexes, then two pages of bare feet.
2. Draw two pages of hands, both sexes, and belonging to people of different ages.

6

ANIMAL MAGIC

There's magic in a fine animal drawing. This chapter explores the right way to become a wildlife artist. The first essential, of course, is to have a good and accurate look at your subject before starting to put it down on paper. This is particularly true when your model is on the move or a long way from you.

I always try to quickly jot down the head and body shape first then follow with the legs and tail. If this is done correctly it doesn't matter if the creature moves about because it's easy to note the details of eyes, nose, fur, markings, etc., but if the basic shape is wrong, nothing will make the finished picture look right.

Though I'm able to draw straight off with a pen, I have mentally recorded the general size and shape of the animal. If you work the same way don't bother about mistakes, these will begin to disappear as you progress, or rather, as your looking improves.

Where to go

Zoos, wildlife parks, and museums – where your model keeps still – are good places for a wide range of subjects. I've spent many hundreds of happy hours in these places just watching and drawing. I sometimes seem to be an exhibit myself!

Zoo animals

Have a look at figures 41 and 42. Note the simple style and

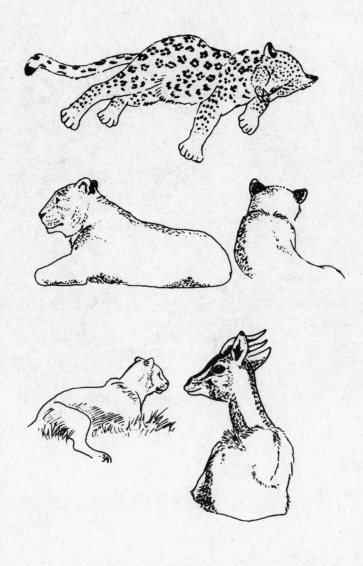

Fig. 41 Try drawing animals in resting poses.

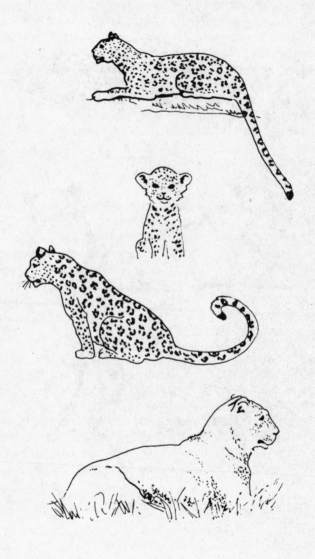

Fig. 42 The Big Cats always make interesting subjects.

the fact that most of the animals were resting or in still poses. It's very often worthwhile to wait until an animal settles, but always be prepared for it to move, so get it right fast and you will have little trouble. It is possible to draw from TV wildlife programmes when the camera shots are just 3 or 4 seconds long, even easier if you have a video with replay. What you need to do is memorise the shape and see it in your mind's eye, then draw it quickly. You can then take time putting in details and markings.

Make a start by drawing or tracing the examples in figures 41 and 42, then have a go at 43, which shows how to get the head and body shape first.

An elephant

An elephant is considered hard to draw accurately, so it's important to get the basic parts right. Try sketching egg shapes for head and body, the blunt end is at the rear. Then put in the thick legs with guide lines Notice how the wrinkles are drawn in the finished picture, and the shading is used to give depth. Remember to jot down the trunk wrinkles, bags under the eye, and sweeping tusks which are adapted canine teeth. This particular elephant is an African one so it has huge ears and a sloping forehead.

A gorilla

The gorilla, figure 44, was rapidly drawn with a type of pen which gives a very fine line, ideal for straggly hair. The basic shape of head and body were recorded first then the massive arms, pot belly and a few facial details. The gorilla ambled off almost at once, but filling in the hair, and straw around it was then easy. The drawing took less than five minutes. You might try drawing first in pencil, then pen. Each medium has its own attractions.

Polar bear and leopard

Figure 45 shows a polar bear and a leopard (I love all the cat family). Both of these subjects were sketched from TV programmes in seconds, but the spots and fur details were put in afterwards. This trick can also be done with human animals on the box.

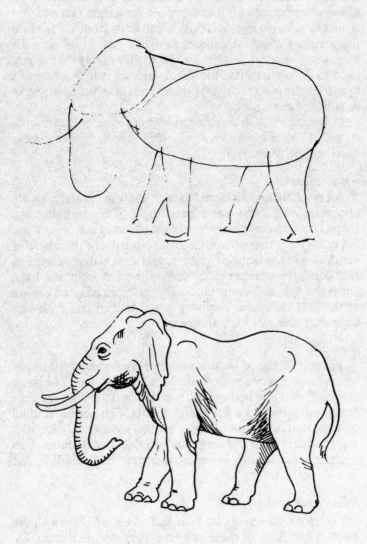

Fig. 43 Get the correct body shape first.

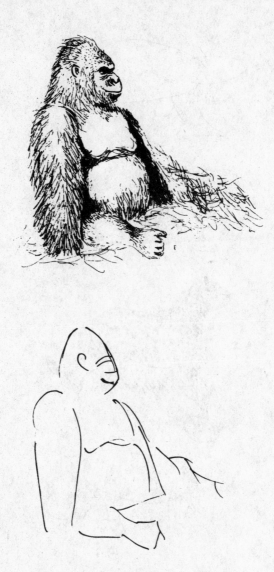

Fig. 44 Choose animal 'models' from zoos, wildlife parks or museums.

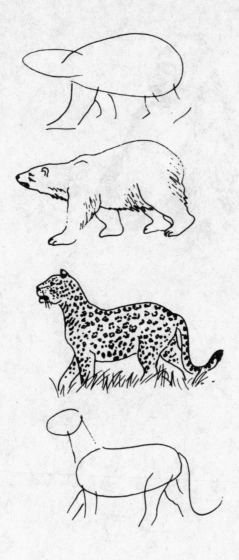

Fig. 45 You can even sketch from the television.

Big cats

The tiger portrait in figure 46 was drawn from an ordinary Biro which was all that was available at the time. You don't always need expensive gear to produce a good picture. Picasso often seemed to use what was nearest to hand. I hope this doesn't prompt you to portray the family moggie in the middle of Mum's best lace tablecloth!

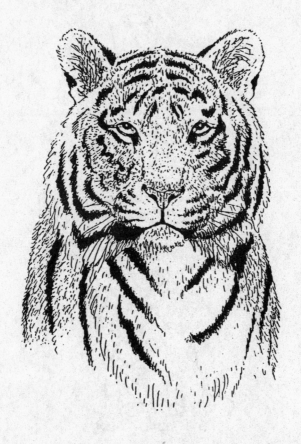

Fig. 46 Great drawings can be made using an ordinary Biro.

Pets

Cats and dogs are popular picture subjects. Try copying the dog in figure 47. See the simple shading under the chin and the belly. The little white patch in each eye is called a highlight, it's used to bring life to the drawing. Always remember to put this in if your model is drawn at close quarters.

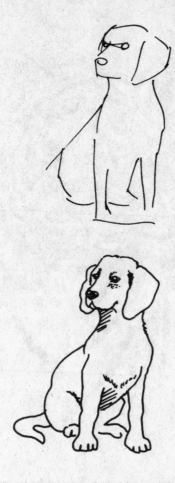

Fig. 47 Immortalise the family pet!

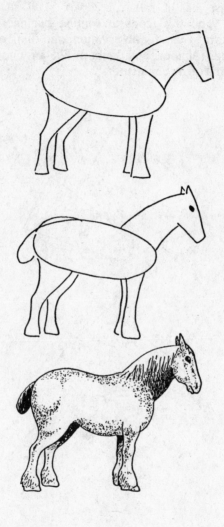

Fig. 48 Horses can be confusing, so begin with careful observation.

A horse, of course

A horse has a rather complex skull shape, like the elephant, and this tends to confuse beginner artists. You should start by careful observation, and think of the head as being wedge shaped, and the body like a rounded oblong, or constructed on an egg shape.

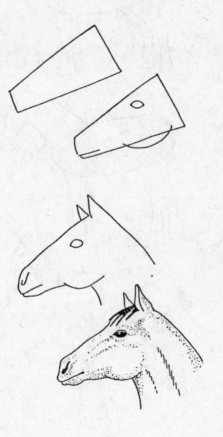

Fig. 49 Think of the horse's head as being wedge-shaped.

Have a shot at figure 48. This is one of those wonderful, hefty work horses that are once again becoming popular. Notice how the basic body and head shapes have been drawn with the legs simply done. The finished drawing shows areas blocked in to give shadow under the mane, and on the far legs. The animal was light in colour with dark grey mottling and spots. These were done by tiny dots, smudges, and circles. Not too hard was it?

Now try the horse head in figure 49. Again we use a wedge shape for the skull shape. Lightly pop in the eye, nostril, and cheek. Work more details in until your effort looks like the finished drawing. Rub out stray pencil marks, ink in or leave as a pencil study.

Make them funny

Animals are great for turning into funny cartoon characters. Walt Disney made a huge fortune from this idea. You too might raise a little money with comical animal drawings. Try a few just for fun. The best way is to play about with a pencil or pen until something finally emerges. This can happen quickly or take ages, but don't dismiss cartoons, they are an art in themselves, and express the unique personality of their creator. The vulture in figure 50 was produced by a student after one visit to a zoo, and with no previous experience of animal cartooning. It's a bit of animal magic.

Human animals

In wildlife parks or zoos you will see people watching the animals, and it's fine to draw a few sketches of them. See figure 51.

Assignments

1. Draw your cat, dog, hamster, budgie or neighbour's pet, including a tall, cool blonde, or toyboy – as the case may be!
2. Draw four different animals from life, or from good photographs.
3. If you go to a zoo, wildlife park, or museum, also draw four or five people looking at animals.

Fig. 50 Animals make great cartoon characters.

Fig. 51 Don't forget to sketch the human animals, too!

7

WATCH THE BIRDIES

After all the practice you have now had drawing animals, it's time to try sketching birds. There is a huge range and variety of our feathered friends to choose from, and the method is the same – looking properly, getting the basic shape more or less right, then adding in the details.

Be gentle with them
There is one important difference about drawing birds as against animals. It's a little change in technique. Because of its delicate structure, slender legs, feathers, and beak, it is necessary to use much finer pencil or pen strokes. See the birds in figures 52 and 53. These were done quickly with light strokes. Notice how much head and body shapes vary between one species and another.

Copy or trace the examples first, then have a go at the marsh tit which is shown in stages in figure 54. This charming small bird is black, white and grey which is good for pencil or pen work.

The robin is considered to be Britain's most popular bird. Each Christmas we see hundreds of cards showing this bright little bundle of feathers. It is much better produced in colour, but good practice to do in black and white. Have a good look at figure 55, and do your version of it.

Figure 56 shows a little ringed plover (top), and a small shore bird called a knot. These grey-coloured waders are common around our shores, and look very attractive as they rest on one leg with head tucked into wing feathers. The one

Fig. 52 There are many different types of birds to draw.

legged pose is common to many resting birds.

The little ringed plover nests amongst shore stones and pebbles and is hard to see from even close range, but when it searches for food it darts about very quickly. It has a distinctive high forehead with bold black markings. Try drawing both birds in ink.

Fig. 53 Head and body shapes vary greatly between species.

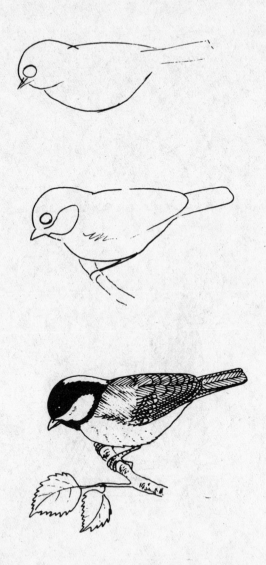

Fig. 54 Build up your sketch in stages.

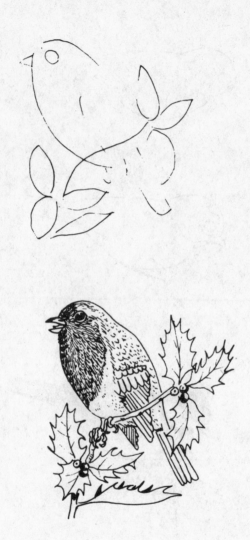

Fig. 55 Many different robin illustrations are seen at Christmas-time.

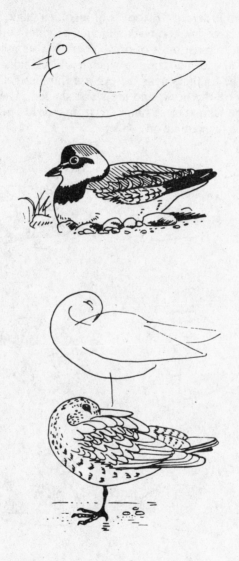

Fig. 56 The one legged pose is common to many resting birds.

Heads

The head in figure 57 (top) is of a golden eagle. Note the flat head, large hooked beak and angry-looking brow which is common to most birds of prey. There is a semi-bald patch in front of and around the eye which has black hairs sprouting from it. The feathers near the eye are tiny but get bigger as they grow on the neck, and are spear shaped. These details can only be seen at close range, or from a dead one, which is how I came to examine one once.

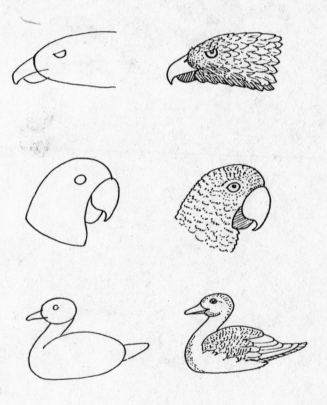

Fig. 57 Notice these different head shapes. Ducks are an easy shape to remember and draw.

The macaw's head is quite different in shape, rounded, and it has a thick bill, as do most of the parrot family.

Ducks

The duck (at the bottom of fig. 57) is an easy shape to remember and draw. This particular one had brown and grey mottling on the upper body, but was snowy white underneath, with black tail feathers. See how these have been drawn, then have a try yourself.

Draw them dead

The great tit in figure 58 was produced as a scraperboard drawing. (See chapter 12, p.116). This medium requires the

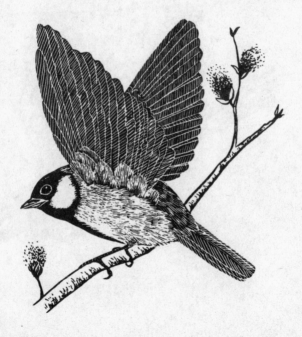

Fig. 58 Most wildlife artists need to go to a lot of trouble to obtain an accurate picture.

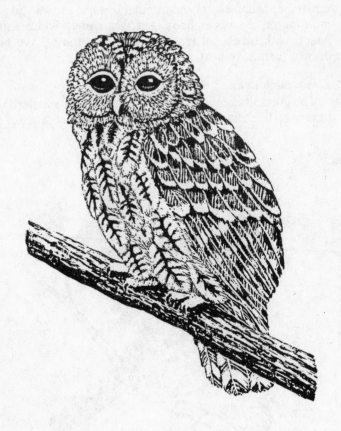

Fig. 59 Owls are a very popular subject.

artist to scratch out the details with a metal tool that can be round, pointed or triangular. The silhouette is first painted in ink on white scraperboard then, when dry, is cut out to give a white, fine detailed picture. The great tit shown was first drawn in pencil from a dead one which had tried to fly through a glass window pane, poor thing. It was pinned out and each primary and tail feather carefully counted and recorded. Most wildlife artists need to go to a lot of trouble to obtain an accurate picture. Try to copy this drawing in pencil or ink.

Owls are liked

The tawny owl in figure 59 is another scraperboard drawing. Owls are a very popular subject. Many people collect owl paintings, models and drawings. Copy or trace this picture and see what result you get with whatever you use. Each medium will produce a different picture.

Assignments

1. Draw a page of garden birds. If you live in a flat rush out and borrow or buy a bird guide book, it will be very useful to you.
2. Most days we see pigeons, crows, starlings, sparrows, or perhaps a blackbird. Try quickly sketching some of these as they feed, perch, or fly.
3. Try to draw the heads, in detail, of four quite different birds.

Museums, zoos, and bird reserves are good places for studying and drawing birds.

8

TREES THE EASY WAY

Some beginner artists are put off drawing trees because they think them a difficult subject. This is true if you try and draw every leaf, branch and twig. A few budding perfectionists attempt this and end up with a mess.

Trees live

Trees are not solid objects, but the commonest mistake is to draw them as if they are. Trees move and sway about in the prevailing wind, and it is usually windy. Daylight shows through foliage, and it's important to remember this.

We have many kinds of tree and could do with more to benefit our atmosphere, by adding oxygen to it, improving the ground by fertilising it naturally, and being host to a vast selection of wildlife. For most of us they are a joy to see, and to draw.

What shape is it?

The first step, as usual, is to have a good look at your subject. Ask yourself whether it is quite round, tall and pointed like a poplar, or similar to those we see at Christmas with a faded fairy stuck on top. If you don't have a tree handy to study, start by copying the one in figure 60. Put down the basic shape, in ink, with thin, dotted lines, then the trunk. Next add a few branches that are glimpsed through gaps in the leaves. You then suggest the light and dark patches of foliage by using fine shading, blobs and dots. Notice how the deepest shadow is shown by simply blocking in. It is useful to

imagine that half the tree is in shadow and half in sunlight. This helps to get depth, and can be used when there's no sun about as on a typical English summer day!

The examples in figures 61 and 62 are of different trees. Draw these in ink using the same technique, then after finishing them try the exercise in soft pencil. See again how leaves are suggested by fine blobs, dots and lines.

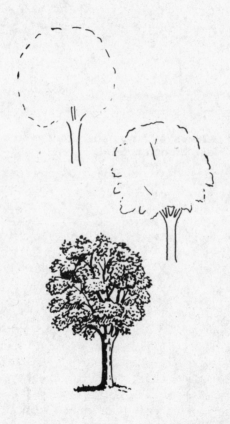

Fig. 60 Remember! Trees are not solid objects.

Fig. 61 When sketching trees, don't try to draw every leaf, branch and twig.

Fig. 62 Try drawing different shaped trees.

It's easy to see the way trees are constructed in winter when they stand bare against the light (unless they are evergreen), and this is a great time to practise drawing them. There are fewer problems than when leaves are out, but the task takes longer. See figure 63, have a shot at it or go out and draw one from life, which is much the better way of learning.

Draw old stumps

You might find it absorbing and interesting, as I do, to draw in detail old tree stumps, roots and leaves. There's something very attractive about wood. Have a look at figure 64. This quick sketch, in ink, was made when out rambling, and took about ten minutes. Closer examination shows various degrees of shading and quite large areas of black shadow. Try this or find one of your own to study.

Fig. 63 Winter trees are easier to draw, but take longer.

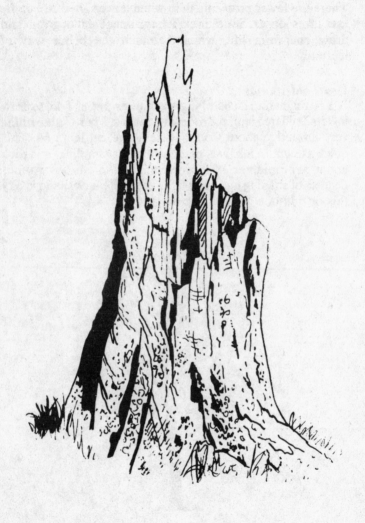

Fig. 64 Old tree stumps make excellent subjects.

When you look at trees you will notice that the way they are shaped differs from one species to another. Leaves can be in dense bunches, sparse, droop down, or grow upwards. All make interesting patterns which have occupied artists for centuries. If you examine the wonderful paintings by John Constable you might think that each individual leaf had been painted in, but this is not so. Constable was so skilled, he gave this impression.

Fig. 65 Trees are best drawn with a soft graphite pencil.

More trees

It's your turn to record a few trees for posterity; try those in figures 65 and 66. These studies were first rapidly done with a soft graphite pencil which, for me, is the best one around for this type of work. (The drawings were repeated in ink for this chapter.) You can get different shades of grey with a soft pencil just by increasing or decreasing your pressure on it. This is ideal for trees, also rock, brick, animal fur, and many other subjects which we shall tackle.

Pencil work is liable to smudge when finished if it is handled, so when you produce an exceptional picture it would be worthwhile fixing the drawing with a light coat of spray. This aid can be had from most stationery or art shops. It's expensive but one container will last a long time, and fix many drawings.

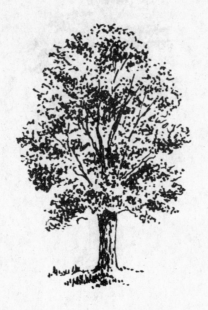

Fig. 66 Try repeating your tree drawings in ink.

Perspective

When we see trees as part of a landscape out in the lovely countryside, we know that the tree which is nearest to us appears to be large, while those in the distance are small to our eyes. In order to draw this correctly we need to know a little about perspective. Perspective applies to anything we draw – humans, animals, or still life. Usually it is a word that strikes terror into the hearts of newcomers to art, but it's not difficult to learn. By now you will have already drawn perspective automatically into many of your life sketches by simply putting down what you saw, so don't be afraid to learn the theory.

If, for example, you were standing in the middle of a straight road and looking ahead into the distance, an imaginary line drawn level with your eyes would be the eye level. All parallel lines to your left and right would appear to converge to a point dead centre of the eye level, and this is called the vanishing point. Suppose on your left hand side is a row of pointed trees that stretch down the road to as far as you can see, then the lines disappear into the vanishing point. This is shown in figure 67. We shall study more about this in

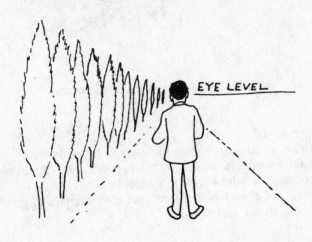

Fig. 67 The Vanishing Point.

depth when we learn about how to draw buildings in chapter 11, page 110.

To get to know about this subject, try a few checks as you rush to the bank or station. Hold a pen or pencil along the edge of a roof that you see before you, or along the kerb, road or pavement. You will notice at once how lines meet at the vanishing point on your eye level.

You might care to try a landscape with trees such as the one in figure 68. This was sketched in just over half an hour.

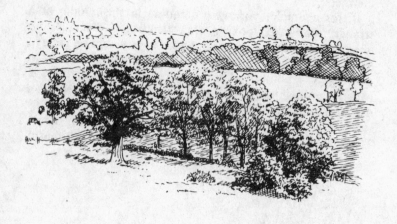

Fig. 68 Include trees in a landscape.

Assignments
1. Draw in ink a tree from life. Avoid fussy details.
2. Take a walk into a park, or where there are different sorts of tree, then draw four in pencil.
3. Find and draw an old tree stump, root, or piece of grained wood, in ink and pencil.

9

HAVE WATER WITH IT

This chapter was to be mainly about drawing landscapes, but as most of the scenes include water, this seemingly tricky subject is explored first.

Rain puddles
Walking down a lane, after a heavy rainfall the previous day, I was fascinated by the large pools of still water, the

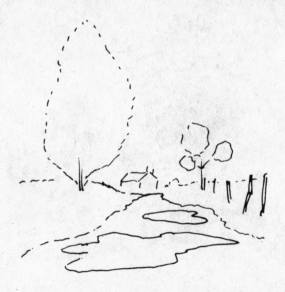

Fig. 69 First jot down the basic shapes of the subject.

house on a distant bend, the fence posts, and the natural composition of the environment. It was ideal for a picture and easy to draw. The basic shapes of the trees were first jotted down, then the fence, puddles and house. See figure 69.

When drawing still water remember that it reflects what is around it. In figure 70, these reflections were put in by using horizontal lines which are close together for dense shadow and further apart for other reflections. You have to think it out when working and, of course, make good use of your eyes. The shading used in the large tree is composed of fine cross hatching, dots and lines. Notice how delicate it is. See how grass in the foreground is bigger and more pronounced the nearer it is to the artist. The house has shaded sides, there is deep shadow beneath the tree suggesting that the sun was almost overhead which, in fact, it was. Strong contrasts of dark and light give the effect of depth.

Try copying this illustration straight off with a pen.

Fig. 70 When drawing still water, remember it reflects what is around it.

Moving water

The waterfall with trees, rocks and water, figure 71, was drawn with a larger size pen simply because it was the only

Fig. 71 Drawing with a larger size pen can produce a very different result.

one to hand at the time. Notice how it appears to be quite bold, compared to the last picture, yet it captures the scene. The shading is more open than in the previous example, but use of deep shadow and light was made. The water needs to be shown as moving. This is done by using small, curved lines to suggest ripples. Patches of blocking in also help.

Fig. 72 Wavy lines, blocking in, circles, dots and blobs all add up to a striking picture!

Figure 72 is a scene from one side of an estuary. The sea nearest to the eye is shown as wavy lines with just a bit of blocking in. Patches of seaweed on the beach are easily done by using a series of small circles, dots and blobs. The same technique is used to depict forest in the distance. Isn't it easy – when you know how!

When water is shallow and disturbed, as in figure 73, the artist is faced with a lengthy job. The dark shadows are put in with lots of wavy lines, then filling some of them in. Possibly the hardest thing about recording water scenes is the patience required, not the actual drawing.

Fig. 73 The artist has a lengthy job when water is shallow and disturbed.

The lock, in figure 74, took over an hour to draw due to all the shading required. See the cross hatching on the walls, and the way reflections were put in. Just to test your staying power, try this one in ink.

Have a look at the sketch in figure 75. Here reflections were done by many horizontal lines, oblongs and ovals. There is always more than one way of doing things, so feel free to do your own thing when it comes to shading. We all have our own unique style.

**Fig. 74 Note the effect of cross hatching on the walls
and the way the reflections are drawn.**

I'm one of life's little sunflowers, so on a very cold day I
stayed inside the car to draw the scene in figure 76. Don't tell
anyone! This picture was needed for a book on rambling! The
work took over an hour, similar to the lock, but what a
different picture. It's a study of very fine shading done with a
fine pen. You will see lots of cross hatching, and shading of
all sorts. A drawing like this is good practice. Bridges and
tunnels offer a different challenge. It pays to try everything.

The ink sketch, figure 77, was done from a photograph
shortly after a walking holiday. Notice how shading has been
used on the rocks, and how a few, small horizontal lines can
suggest sea in the background. It's the simple ways that are
the most effective in many drawings. Beginners tend to want
to try and show every detail. While this is perfectly natural

Fig. 75 Feel free to do your own thing when it comes to shading.

**Fig. 76 Very fine shading with a fine pen produces a
 different picture.**

**This picture is reproduced, with permission, from "Let's
Walk" by Mark Linley, formerly published by Meridian
Books.**

it's also the commonest mistake. An illusion of depth, in this
illustration, is helped by the tuft of grass in the foreground. It
was from this point that the photograph was taken. A camera

Fig. 77 Simple suggestion gives the best effect in most drawings.

is very useful for the busy artist who runs out of time, or sees far more than can be drawn in a given time.

Clouds as well

Many landscapes should contain clouds, and we have had a little go at these earlier, on page 28. But expertise is only gained by doing lots of drawings, and most days in our climate we have clouds to see. Notice how clouds have dark, light, and medium tone areas, how some edges are sharp, some blurred. These can be drawn as broken, dotted, or thin lines depending on what you want. Clouds can be drawn with a soft pencil which can be smudged with a finger to give the right effect. Often, however, a good ink drawing is enhanced by putting in clouds, so don't be afraid to do this.

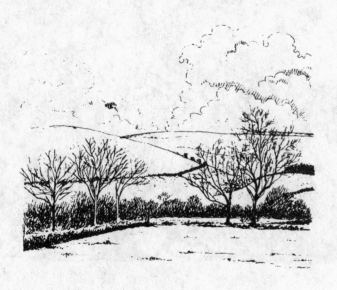

Fig. 78 Many landscapes should contain clouds which can greatly enhance a drawing.

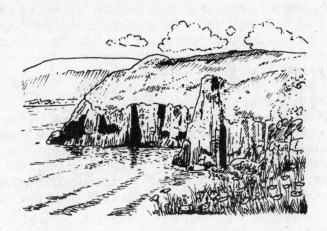

Fig. 79 Remember to use light and dark shading to show depth.

The sketch shown in figure 78 was made after a walk on Exmoor. It was in early Spring, with billowing clouds, bare trees and rolling, open hills. Pictures such as this are easy to do if kept simple, with attention to things like branches and hedges.

The coastal scene in figure 79, was drawn from a cliff top, and presented no difficult problems. Normal shading and attention to flowers and grass in the foreground were all that was required. Again, it's quicker and more effective to do a drawing with as few lines as possible, but to remember light and dark for depth.

Always try to take a sketch book with you on holiday or when visiting unusual places or events. There's certain to be something worth recording, and it may be weeks, months or years before the same environment is seen again. Very often, drawings done "on spec" can come in useful long after they have been produced, for illustrating books or articles, or for exhibiting, for example.

A camera

A compact camera is ideal for the artist who travels and wants a wide angle shot of the countryside or of buildings. These neat cameras give quite superb photographs, and with automatic focus are almost totally foolproof for those who know nothing about this skill.

A big landscape

Newcomers to landscape art sometimes become confused when faced with a vast panorama, but there's one dodge worth knowing. Choose your picture by deciding what points should mark the edges of your work. Or, better still, make a rough square with your hands and view possible compositions through it. See figure 80. This trick is useful on all pictures,

Fig. 80 Make a rough square with your hands through which to view possible compositions.

not just landscapes. By moving the hands near to you or away, the size can be adjusted. Then you can get on with your masterpiece and ignore surrounding distractions.

Keep notes

It is worthwhile to keep notes of the things that might come in handy in a picture; old wooden gates, fences, farm buildings, and people. All can add much to a picture, and it's enjoyable practice – the more you do, the better and faster you become.

Don't forget that a picture can be given a sense of scale by including the figure of a person, or an animal. See figure 81.

Fig. 81 Give your picture a sense of scale by adding a person or animal.

Assignments
1. Draw two scenes from old calendars or postcards. Keep them simple.
2. Draw two scenes with trees and water, from life.
3. Make some notes of clouds that you see. Ink and pencil.

10

IF IT'S STILL, DRAW IT

Still life is an art form in its own right, and whole books have been devoted to this subject. It is very traditional to churn out the odd picture of bowls of fruit, bottle with glass, tea cups, vases of flowers, etc., but many people have been put off this fascinating pastime by having the subject badly taught or thrust at them when at school.

The subjects for this book have been chosen because they can be used in many general pictures, and are good exercises as well.

Don't eat it first

I found that a newly baked loaf of bread as a background to a hunk of cheese was an excellent model. The trouble was that it got eaten before the drawing was finished. Some of us artists are greedy, or just plain starving!

Collect old wood

Old wooden gates are among my favourite items to draw. The ancient bars and pieces show wonderful grain lines with lots of different tones, then there's the added attraction of bygone craftsmanship that went into the making of them. Today, of course, many new gates are made of steel, which isn't nice to look at, but it's cheaper and lasts longer than wood. With old gates there are usually equally elderly posts which are lovely to sketch. See figure 82, then try drawing it, or better still, go out and find one to draw from life.

Dead tree stumps, fence posts, roots and branches are

Fig. 82 Old wooden gates and posts make attractive drawings.

other subjects which are easy to draw. Driftwood that has been cleaned by river or sea then bleached by the sun is attractive to sketch. Some shops sell pieces of this as highly varnished, highly priced ornaments. The branch shown in figure 83 was found on the banks of an estuary. It's very useful indeed to keep ink sketches of objects such as this because they can be added to pictures to improve composition or fill in gaps. See how the fence posts and battered gate add a little to the drawings in figures 84 and 85.

Fig. 83 Try collecting driftwood to sketch.

Fig. 84 Improve the composition of your drawings by adding fence posts and a battered gate.

Fig. 85 Old wooden posts can add something to a picture.

I use a fine pointed pen for this work and have found that by decreasing finger pressure on the pen, very thin, delicate lines can be produced. This is a help in recording, for example, the fine lines of wood grain, or those seen in leaves or flowers. Examine the posts in figures 86 and 87. Bits of bark, cracks and knots in the wood all help to make an

Fig. 86 Bits of bark, cracks and knots in the wood can be most effective.

attractive drawing. Try your hand by copying these, then look around for some to do from life.

An unusual tree, on a windless day, is a good still life subject. In figure 88 the leaves were shaded in, just to try something different – which is to be recommended in most art forms.

**Fig. 87 Try drawing a specific area of an old wooden
post, to highlight the detail.**

Plants

Notes made of plants and flowers can be very useful for
pictures. These are not hard to draw provided that you look
carefully first, as I'm sure you now do. First put down an
accurate basic shape then work it into a finished drawing.
Always follow the same procedure, then it becomes a good
habit. I'm no botanist and quickly forget the proper names of
plants and flowers, but this doesn't stop me from admiring
and drawing them. Ivy leaves are nice to draw and make
pretty compositions; take a look at those in figure 89. You
often come across this plant on buildings, trees and old
fences. Again, you can add them into pictures with good
effect. Start with the basic shape of the leaves, then simply
put in the details.

Fig. 88 An unusual tree is always a good still life subject.

Flowers
 Generally speaking, flowers are much easier to draw than
to paint. If drawn, the first thing is getting down the correct
basic shape. Then add in the details of petals, stems and so

**Fig. 89 Ivy leaves make pretty compositions and are nice
 to draw.**

on. But to paint flowers is a harder task, many colours may be
required and dozens of tones. Lady artists shine at this,
possibly because they have a more delicate touch than men.

A white flower with an orange centre, sketched for this chapter (figure 90), was an ox eye daisy I was told. Take a look at the flowers in figure 91 then try to draw flowers using the same easy system.

Fig. 90 It is usually easier to draw flowers than to paint them.

Draw flowers by using those around you which may be in a garden, window box, pot, or good photograph.

Grass
Clumps of grass are fine to draw and useful for putting in the foreground of pictures. The grass in figure 92 is of the ordinary lawn sort left to run wild. You guessed right, it's a bit of *my* lawn!

Fruit
Fruit of all sorts crop up in many still life pictures. I was instantly attracted to great bunches of delicious looking blackberries when out in the countryside, and made the ink drawing in figure 93. Notice how this simple subject can be a

Fig. 91 Try drawing flowers using this easy system.

**Fig. 92 Clumps of grass are useful for putting in the
foreground of pictures.**

Fig. 93 Many different sorts of fruit appear in still life pictures.

study of strong contrasts, black and white. When this picture was finished – I ate them!

Assignments
1. Draw a page full of plants from life, if possible.
2. Do the same with old fences, gates or posts.
3. Draw studies of dead branches.

11

BUILDINGS

Old buildings, for me, have far more charm, character and art than modern plastic and glass erections that are thrown up all too often today. This chapter is about drawing the sort of thing that brings a glisten to the artistic eye.

More perspective

You will remember that we touched on the subject of perspective in chapter 8 (page 85). We need to know a little more about it for sketching buildings, but there's no need to call for a strong drink or reach for an aspirin, it won't be painful or too difficult.

Get it right

The would-be masterpiece of your Great Aunt's thatched cottage in the country, with roses round the door, will look quite wrong if the perspective is incorrect. All the lines of roof, windows, doors, sides, etc. must converge to a vanishing point on your eye level at the time you make the picture. This eye level will stay the same, unless you jump up and down, climb a ladder or drop into a hole, so once it's fixed, all lines will lead to it. See figure 94 and this will explain what is needed. Put in the lines lightly with a soft HB pencil which can be erased when your drawing is right.

See figure 95 which shows how to deal with perspective that is to one side of you rather than in front. A row of trees is used; notice how the dotted lines vanish into the eye level. Try a few drawings which show things in perspective – your

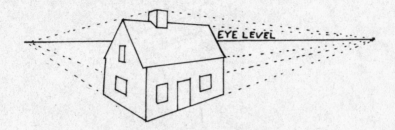

Fig. 94 All the lines of a building must converge to a vanishing point on your eye level.

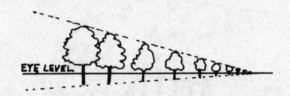

Fig. 95 This shows how to deal with perspective that is to one side of you rather than in front.

garden shed, a bus shelter, or garage.

Bits of buildings

You may be full of confidence by now and feel able to tackle a whole building straight off, but if you are not it's good practice to start by drawing a page or two of building parts. See figure 96 and do likewise.

When you are drawing buildings, or anything else, ask yourself these questions: What shape is it? What shadows are there? How can you get that effect? And so on. If problems like these are thought out first (and it's done in seconds), the picture will be that much easier.

Fig. 96 It's good practice to start by sketching bits of building before tackling a whole one.

It's useful to collect notes of stone, brick and walls. These can be used in future drawings. It's always good to keep your best sketches. For example, many of the fast ink drawings in my note pads have been used to illustrate this and other books. *Sketches may become valuable to you.*

Draw old ruins

A good way to begin drawing buildings is to have a look at old ruins such as ancient castles. See figure 97. This is part

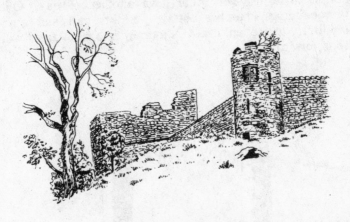

Fig. 97 A good way to begin drawing buildings is to have a look at old ruins.

Fig. 98 Old farm buildings, castles, cottages, bridges and mills are lovely to see and draw.

of Dudley Castle (the zoo is within its grounds), and it was drawn during the afternoon spent making sketches of the animals for chapter 6, Animal Magic.

The drawing in figure 98 of an old, tumbledown barn was done from the inside of my car (it was another cold day!). Old farm buildings, churches, cottages, bridges, mills and so on are lovely to see and draw. A journey into rural areas will soon reward you.

Fig. 99 Shadow falls away from the light.

Start by drawing the perspective, in pencil, then the main parts, roof, sides, chimney, doors and windows. Add in details of brick or stone work last, but don't overdo this, just suggest a few. Finish the picture with trees, bushes, flowers or what you see.

Let there be light and shadow

All pictures need contrasts of light and dark, or shadow, particularly buildings. If there is no bright daylight or sun you can still put this in, but get it right. Figure 99 shows how shadow falls away from the light. Shadow that is near to you tends to look lighter than that away from you. You must decide whether to block it in or shade it. Look at the example again.

Indoor lighting

While we're on the subject of lighting, do you require special lamps or bulbs for indoor sketching? Not really, a good even light is fine, not too bright, and not too dull. Fluorescent tube lights are good, or a table or desk light. I usually manage with what is around, but never work in poor or half light.

Specialise

Some people coming into art try the various subjects previously covered in this book, but suddenly shine when drawing buildings. Then they devote almost all their future efforts to this interest. If you are taken this way, by all means follow your star, but don't neglect other subjects. It might be wonderful to draw the perfect picture of your Great Aunt's thatched cottage, but it's not so good if the roses round the door look like a tattered wreath because you haven't bothered with flowers.

Assignments

1. Draw a page of building parts from life.
2. Draw a building from life, with background.

12

SCRAPE IT OUT

Scraperboard (called scratchboard in the USA) is a super medium for producing animal pictures because one can get an illusion of real fur. See the squirrel in figure 100.

The material is made up on cardboard. The manufacturers keep the ingredients secret, but it's generally thought to be a mixture of plaster which is baked onto a surface. It is very hard and brittle and cracks if bent or dropped. Care is needed when working with it.

The picture is cut or scratched out with a steel nib-like tool which can be triangular, pointed or curved. In fact, any sharp point will do, but I have always preferred the triangular blade for normal work, and a curved one for clearing large areas.

Black scraperboard

The black scraperboard gives a picture of white against black, of course. It shows the smallest mark and mistakes can rarely be put right, so it's very important to get the basic drawing correct. I do this by drawing out on tracing paper, in ink, exactly what I want the finished picture to look like. Then I rub chalk on the reverse side of the paper. This is to obtain a result similar to using carbon paper, but white on black, of course. The drawing is then transferred to the scraperboard with a fine pen, or pointed tool. There is then a white-lined drawing to cut out or scratch. The squirrel, figure 100, was done this way, and has been produced as a Christmas card.

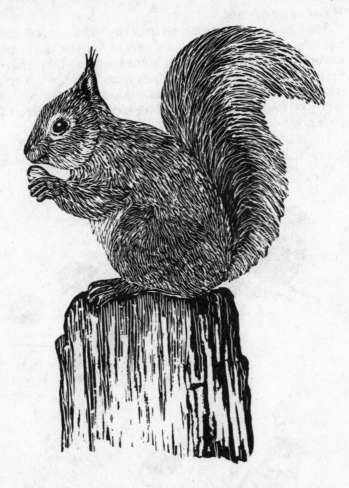

Fig. 100 Scraperboard gives the illusion of real fur.

Years ago, before the days of modern print making, many very famous artists did magazine and paper illustrations with scraperboard. It is one of my favourite mediums, and one to be recommended to all aspiring artists. It is comparatively expensive today, so careful planning and drawing of the design to be scratched out are essential.

White scraperboard

Some beginners trying this art form buy white scraperboard and attempt to cut out a picture, only to find that the board has been ruined by their efforts. White board has first to have the design painted on as a black silhouette which, when dry, is then cut out. It's best to use thick quick-drying ink. This is a very good medium for birds. The owl, and great tit in chapter 7 were done on white board.

Have a long look at figure 101 of the little marsh tit. This starts off as a black silhouette, then the main lines are cut in

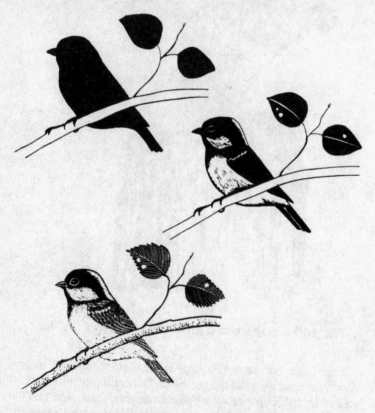

Fig. 101 When using white scraperboard, start with a
black silhouette. Cut in the main lines, then
carefully scratch away the rest.

and the rest carefully scratched away. Branches are drawn with a fine pen, but leaves cut away. Notice how the lines in the leaves all go one way; this is shading, in effect. A master drawing of this bird, in ink, was constantly referred to as the work went on.

Landscapes can be done with scraperboard as well.

One big advantage of this medium is that it mass-produces well and allows very fine lines to be used. On an animal picture, for example, there are about fifty tiny cuts to the square inch, and these lines must go the same way as the fur grows on the real thing.

Foil

Scraperboard comes in foil as well. This gives a gleaming picture when cut away. I don't particularly like this, and find it not so good for wildlife pictures, but maybe it's just because I've used black or white for many years now.

The way to cut is quite natural, you hold the tool just like a pen and scratch away. It causes a fine layer of dust to settle everywhere, over the table, the cat, and up the artist's nose! Blow it away from time to time; this helps!

Assignment

1. Buy a packet and try it out on whatever you fancy.

13

CARTOONS FOR FUN

Of all the mediums I have tried, cartoons give the most freedom to express one's own thing. It's not necessary to stick to lifelike proportions, or even to try to get a likeness. You can invent exactly what you like, and have fun doing so. Your little cartoon people can have gigantic noses, huge eyes or feet, three fingered hands, and so on.

Fig. 102 If your cartoons amuse you, they're sure to brighten the days of others.

It's wonderful to be able to create little people and control their lives and times. If your cartoon ideas amuse you then you can be pretty sure that they will brighten the days of other folks with a sense of humour. See figure 102.

Style

When you have drawn a few hundred sketches, your own style of drawing will have evolved which will be quite unique to you. I have known style happen with some students after just a few lessons. This particular way you record things will affect what your cartoons are like. My own natural style is rather lifelike, and I admire other cartoonists' work far more, but it's what has evolved for me, and it gets me by.

You might have an off-beat style that is funny to look at without captions. If you have, the publishing world is at your feet.

You may be capable of inventing an original strip cartoon like Peanuts with dog Snoopy. These characters have made their creator a multi-millionaire.

Faces funny

Good cartoons, however exaggerated, are based on life. So start by drawing a page of cartoon faces which stem from those you see about you; your spouse, children, grand-parents, friends, or strangers. Look first, then draw very fast because this seems to give the best results for cartoons. See the faces in figure 103. These were done during a lunch break when on a ramble. They are true likenesses.

Don't bother at first trying for likenesses. This is called caricaturing and it is advanced art. Feel free to invent new, funny faces, and then have a go at stretching them to their limits.

Be careful

Drawing cartoons is great fun, but it can bring trouble if you are not careful, and I wasn't when at school. I was clipped round the ear for drawing a cartoon of a master. Later, when in the army, I had the bad luck to serve under the meanest sergeant major ever. The poor chap was very ugly and

**Fig. 103 Draw some cartoon faces which stem from
those you see about you.**

seemed to hate all soldiers in general, and me in particular.

To me he resembled a loathsome-looking bald headed
vulture, so naturally I drew him this way. The masterpiece
was stolen then pinned up in the sergeant's mess. It was not
signed, but all my weekend passes were cancelled for six
months, and were spent doing dirty, awful jobs. There's no
justice for some of us cartoonists!

Most normal folk, I'm pleased to tell you, are delighted to
be cartooned, and I'm sure a small fortune awaits me on a
sunny Spanish beach during the tourist season.

Animals

Try turning some of your sketches into animal cartoons.
All of us, since childhood, have seen thousands of animal
characters in films, books, magazines, and on TV. In spite of

Fig. 104 Base your comics on real life.

this massive saturation, beginner artists tend to think it is a hard subject, but it isn't really. Base your comics on real life. Have a look at the giraffe in figure 104. While this is a true cartoon, notice how near to life it is.

When a zoo or wildlife park is visited I always turn a few of the studies into cartoons just for my own amusement if nothing else. You could do the same.

Press cartooning
A large proportion of the cartoons used by daily newspapers are produced by talented spare-time artists. The

competition is staggering, though. Some editors receive several thousand cartoons each week, but may use at the most about 35.

I churned out newspaper cartoons for a number of years, and it's difficult work. The easy part was the drawing, but after a hard day it was difficult to think out new ideas or different slants on popular themes.

The rewards are high. Most national papers pay well for good ideas, but in order to sell one cartoon it's necessary to produce scores. It works like this: to break into newspapers, a batch of 5 or 6 cartoons, with return postage, are sent each week until the editor accepts one. This can take months, even years. Editors like to be sure that your work is YOUR work before beginning to accept. Don't be put off by constant rejections, just plod away. If you have a very original style and good ideas, you could break in quickly.

Ideas

Thinking out original cartoon ideas requires time. Your mind has to adjust to the job, but when you do get the hang of it, keep a notebook handy or the idea will be lost forever.

The best ideas, I have found, are always those that come from life. In fact, all good humour is based on truth. You can get ideas simply by listening to what people say or watching what they do. As an example of this see figure 105. This cartoon happened like this: a group of us trudged across a huge field of clay during a ramble, and had to keep stopping to knock the stuff off our boots. After crossing over, I heard a lady say triumphantly to her husband, "It's your turn to clean our boots." The idea was ready-made, and it often happens just like that. The drawing was done during a lunch stop and appears in my old book "Let's Walk". That was not the only one, because I had about 16 ideas for rambling theme cartoons and drew them, in ink, in a sketchbook. These led to a contract for a walking book. The moral of this true tale is *always keep sketches*, and if they are funny show them around. You never know what they might lead to.

Now get busy with a page or two of funny characters invented by your fertile imagination.

Fig. 105 "It's your turn to clean our boots."

This picture is reproduced, with permission, from "Let's Walk" by Mark Linley, formerly published by Meridian Books.

Assignments
1. Try looking at animals then turning them into comic ones.
2. Take a good look at yourself in a mirror then draw what you see as a cartoon – and no cheating!

14

FINAL REMINDERS

Congratulations on reaching the last chapter, and on all your work to date. Have you remembered to put the date on your sketches? Now is the time to look back at your very first effort then compare it with your latest creation.

Some newcomers to art are a bit short on self-criticism because they lack experience to see small mistakes. If you think that you are too kind to yourself, and we all are at times, ask a good artist or teacher to give you his honest opinion. This can come as a nasty shock, but don't worry if it does, just learn from it. No true artist ever stops learning.

If, like me, you are never really satisfied with what you have produced, do not bother, because you will always make progress.

Look carefully first

The much repeated *look carefully* is again reiterated as a vital part of being, or becoming, a good artist. If the drawing goes wrong it's almost certainly due to wavering concentration or not looking properly. Look again my friend – you can get it right.

Draw quickly

Fast spontaneous drawings (particularly with cartoons) are usually the best and have an extra something about them which is sometimes missing from careful work. To go too slowly is to encourage doubt to creep in. Be bold, be quick.

Draw plenty

As mentioned before, the more you draw, the better you become. Quantity leads to quality in this case.

Many of my week-course students draw 200 sketches in five days, and most top the 100 mark. Some have said that drawing becomes addictive, and maybe this is true. If so, what better addiction is there for an artist?

Develop the good habit of always carrying a small sketch pad with you, and filling odd minutes by jotting down what is around you. You will make progress and have professional-looking work to show.

Keep the best

In the course of a year you can build up a huge pile of drawings, so it is wise to weed out the bad ones and keep the best to compare with future efforts. Try keeping them in pads which are dated. Later, you too can become a writer and illustrate your books with drawings taken from your sketch pads.

Enjoy it

I believe that one of the secrets of quick learning is to enjoy your subject, and doing it. Don't let it become too serious, or worry about volume of work, just plod on and use your sense of humour as you go. With the right mental attitude you will then always look forward to the next lesson or session, and making mistakes won't bother you because you will take them in your stride and expect them.

Have courage

You should have the courage of your convictions as an artist, and I'm sure that you will have the nerve to go any place and draw anywhere regardless of what other people think or do. You might, for instance, decide to stand in a busy street and sketch folk around you. This can be fun and not nerve racking at all; in fact, strangers may smile and talk to you – just for being an artist. It's one of the many perks of the trade.

If you want to try something different, go ahead and do it.

You might discover a new art form or medium that will sweep the world. New ventures can lead to many things.

Just going out and drawing from life brings rewards. You may, for example, meet many interesting people and like souls. You learn about life, and record it. Now rush out and make a start.

Use your own computer

Always try to use that wonderful built-in computer in your head, your sub-conscious mind. Its magic power is there for you to use. Remember that your conscious mind is its master. Your sub-conscious mind is your servant, and quite foolproof when given the right instructions. It can work for good or bad depending on how you think, but as most of us artists are peaceful, caring humans, you will program your computer for good. *You can learn to do anything;* never forget it.

Finally, thank you for being my student and for reading this book, and good luck with all your artistic endeavours.

FREE

If you would like an up-to-date list of all **RIGHT WAY** titles currently available, please send a stamped self-addressed envelope to

ELLIOT RIGHT WAY BOOKS,
KINGSWOOD, SURREY, KT20 6TD, U.K.